D0591227

POCKET PAINTERS

RENOIR

1841 — 1919

Renoir

August Renoir (1841-1919) had a more down-to-earth attitude to art than many of his contemporaries, and always saw himself as a craftsman. At the age of thirteen he was apprenticed to a porcelain painter and later supported himself by taking on decorative commissions, while spending as much time as possible at the Louvre, studying French masters such as Fragonard and Boucher. It was not until 1861 that he could just afford to enter the studio of Charles

Gleyre, where he met Monet, Sisley and Bazille, and through them Coubet and Pissarro.

Soon Renoir was applying Impressionist techniques to portraits and nudes, as well as outdoor scenes, and under the influence of Monet his work became considerably lighter and freer. He and Monet would work together beside the Seine, often painting the same subjects in remarkably similar styles. Renoir took part in the first three Impressionist exhibitions, where he had more success than most, and in his paintings of Parisians disporting themselves in the open air he created some of the most archetypal images of the Impressionists' world. Soon, however, he was not only obtaining portrait commissions but, from 1877, exhibiting regularly at the Salon.

This did not endear him to some of his colleagues in the movement, but by the early 1880s, following visits to Italy and renewed attention to the eighteenth-century masters, he was in any case coming to the conclusion that for him the concerns of Impressionism were a dead end, and that *'the only worthwhile thing for a painter is to study in the museums'*.

He began to concentrate almost entirely on human figures, painted in brilliantly luminous colours, and his later subjects were mostly female nudes, which both delighted his eye and suited his palette. Even in his final years at Cagnes, on the Mediterranean, crippled with arthritis and barely able to paint – he would have the brush strapped to his wrist – his work lost none of its warmth and serenity.

At his best, Renoir is one of the greatest ever painters of the human form. If on occasion his treatment of a child can appear idealized, or a nude over-ripe, this is simply because he was entranced by the play of light on glowing, healthy skin. *I always want to paint people as if they were luscious fruit.'* He was an uncomplicated man who had his share of hardship in the early days but enjoyed life, loved his work, and had little time for agonizing or for theories. *'The ideas come afterwards,'* he said *'when the picture is finished.'* ◼

Portrait of Lise

Oil on canvas
1867
181 × 113 cm

Renoir painting of his young mistress, Lise Tréhot, in the Forêt de Fontainbleau is arguably his first great painting. The influence of Courbet still shows, but delicate touches such as the half-shadow on the face are pure Renoir. It was exhibited at the Salon in 1868.

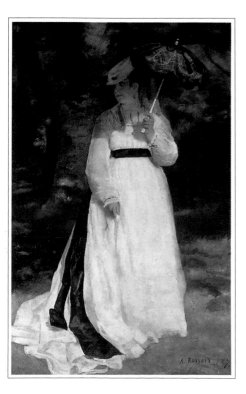

The Path through the Long Grass

Oil on canvas
1873
60 × 74 cm

This delightful evocation of an outing in high summer, painted near Argenteuil, has much in common with Monet's *Wild Poppies* both in atmosphere and composition, notably the ploy of using a repeated pair of figures to provide a sense of movement and depth.

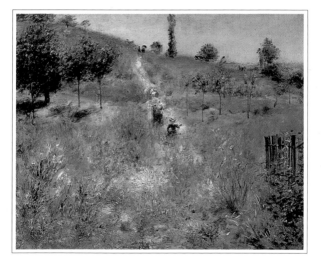

Moss Roses

Oil on canvas
c.1890
35.5 × 27 cm

Renoir produced numerous studies
of flowers during his Impressionist
period. He enjoyed painting them
and continued to do so, frequently
incorporating them into his large
compositions for decorative effect.

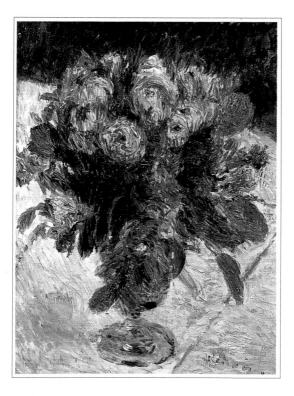

Roses in a
Pottery Vase

Oil on canvas
1885
38 × 30 cm

For Renoir the play of light on rose petals had a sensuality comparable to the warm tints on a woman's healthy skin. He took particular pleasure in asymmetrical arrangements.

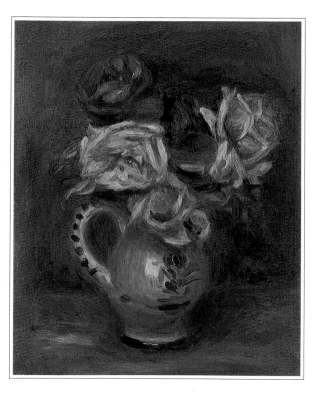

Girl with a White Hat

Oil on canvas
c.1892
41 × 33.5 cm

Renoir loved to paint his friends, and by the mid 1870s his reputation as a portrait painter was growing. Lucrative portrait commissions gave him the freedom to take on more ambitious projects.

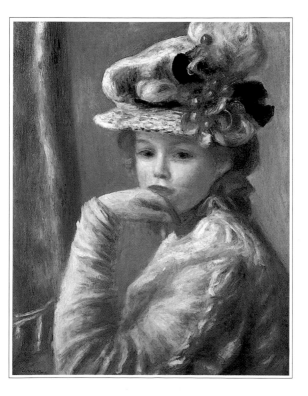

On the Banks of the Seine at Champrosay

Oil on canvas
1876
55 × 66 cm

After spending summers with Mone[t] at Argenteuil, Renoir was on the Sei[ne] once again when he stayed at the ho[me] of the novelist Alphonse Daudet, wh[o] had commissioned a portrait of his w[ife]. There he met Georges Charpentier, who became an important and influential client.

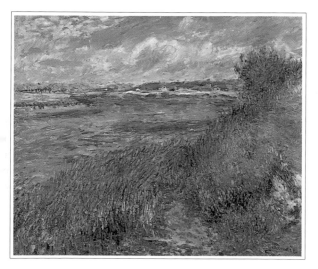

In the Garden

Oil on canvas
1875
81 × 65 cm

Even at this early stage of his career
Renoir was tending to populate his
outdoor scenes with figures, which he
handled with great naturalness. It was
his predilection for painting the human
form which would lead him, as time
went on, to grow increasingly
dissatisfied with Impressionism.

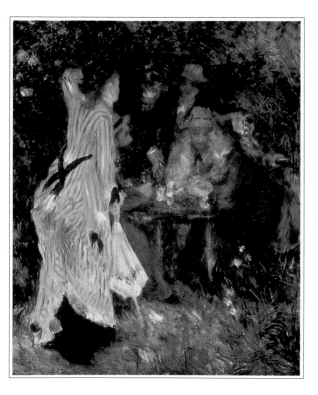

The Swing

Oil on canvas
1876
92 × 73 cm

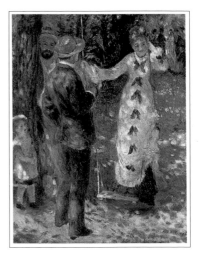

Left – Painted in the garden of the house rented by Renior in the Rue Cortot in Montmartre, this ravishing study in dappled sunlight has great depth and an engaging group of figures. When it was exhibited at the third Impressionist exhibition the following year, critics described it as *'audacious'.*

Overleaf – One of the archetypal images of the Impressionist era, this is also a monument to the principle of painting directly from nature on the spot. Day after day, Renoir brought the enormous canvas back to the open-air dance floor, with the help of friends who also posed for the main figures.

Dancing at the
Moulin de la Galette

Oil on canvas
1876
131 × 175 cm

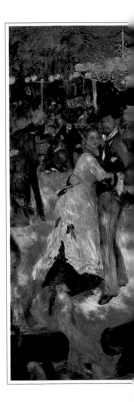

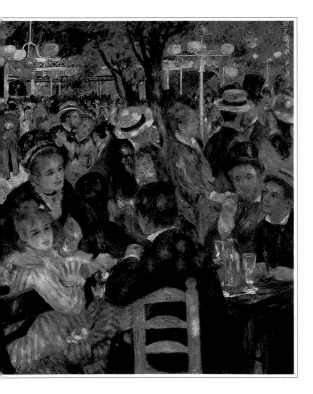

The First Evening Out

Oil on canvas
1876 – 7
65 × 51 cm

This sensitive study represents the perfect marriage of genre subject with Impressionist technique. True to the principle of showing only what the eye sees at a given moment, Renoir leaves the entire background indistinct and focuses purely on the girl's face, thus emphasizing her nervous excitement.

***Countryside at
Berneval***

Oil on canvas
1879
49 × 61.5 cm

Renoir returned several times to
Berneval following his first trip to the
Normandy coast in 1879. Although
rugged coastal scenes did not appeal to
him as subject-matter as much as to
Monet and others, he appreciated the
light and produced some memorable
landscapes.

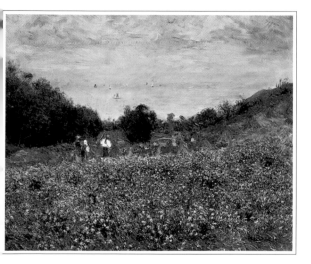

Dancing in the Country

Oil on canvas
1883
180 × 90 cm

A more rounded Aline posed for this, the most relaxed and cheerful-looking of three very similar dance compositions, all of which Renoir painted in the same year.

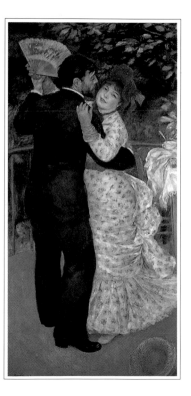

The Rowers' Lunch

Oil on canvas
1879 – 80
55 × 66 cm

The technique is still Impressionist, and indeed the boating scene in the background recalls Renoir's earlier work on the river, but by putting the emphasis on the figures and their pronounced mood of relaxed satisfaction, Renoir seems already to be distancing himself from the abstract values of Impressionism.

Overleaf - In this carefree scene at the Restaurant Fournaise on the Ile de Chatou, only the sketch background is truly Impressionist, while the treatment of the figures is more or less conventional. Moreover it was painted in the studio. Seated on the right is Gustave Caillebotte; on the left, Aline Charigot, whom Renoir would marry.

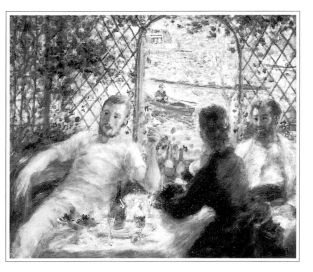

*Luncheon of the
Boating Party*

Oil on canvas
1881
130 × 173 cm

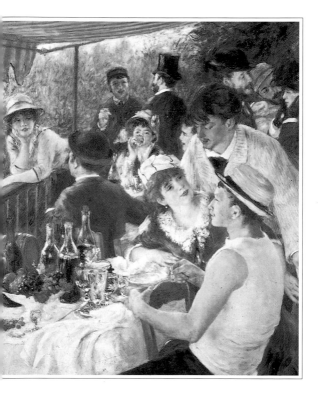

Bather, Seated

Oil on canvas
1882 – 3
54 × 39 cm

Renoir's travels in the 1880s hardened his attitude to the shortcomings of Impressionism. Turning again to the painters of the seventeenth and eighteenth centuries he became increasingly preoccupied with painting the female form. This figure, isolated against the blue background, has a truly classical serenity.

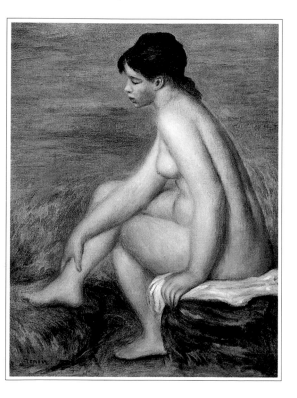

**Woman Drying
her Feet**

Oil on canvas
c.1888
65.5 × 54.5 cm

After experimenting during the 1880s
with his *manière aigre*, or sour style,
characterized by bleached colours,
precise contours and a somewhat
artificial decorativeness, Renoir has
returned to the full range of lush
colours for his sublimely natural
woodland idyll.

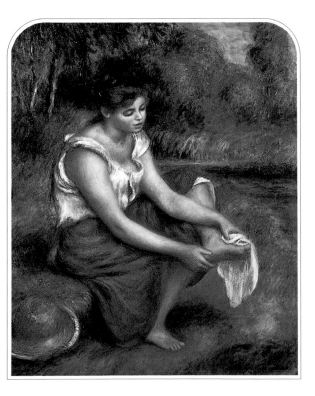

Bather, Standing

Oil on canvas
1896
81 × 61 cm

'I have a horror of the word "flesh", which
has become so shop-worn. Why not "meat"
while they are about it? What I like is skin,
a young girl's skin that is pink and shows
that she has good circulation.' – Renoir

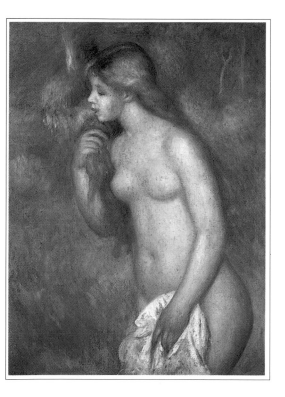

Bather Arranging her Hair

Oil on canvas
1893
922 × 739 cm

In this nude there is a remarkable sense of movement and life which, combined with the warm colours, produced a really satisfying, sensuous production in the Titian tradition.

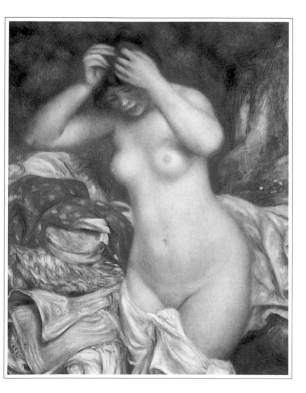

***Blonde Girl
Combing her Hair***

Oil on canvas
1894
56 × 46 cm

By nature the most relaxed and
optimistic of his contemporaries,
Renoir was a life-enhancing figure, the
best of whose later work is a subtle and
vibrant hymn to feminine beauty.

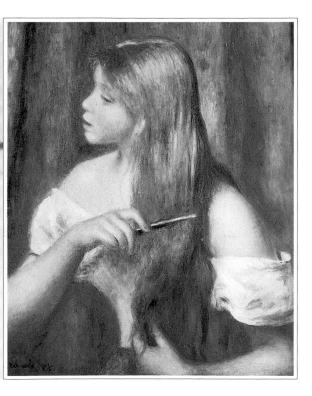

Breakfast at Berneval

Oil on canvas
1898
81.2 × 66 cm

This family scene, painted at a house that Renoir had rented on the Normandy coast, shows his two sons, Pierre, reading, and Jean, the future film director, in discussion with a relative.

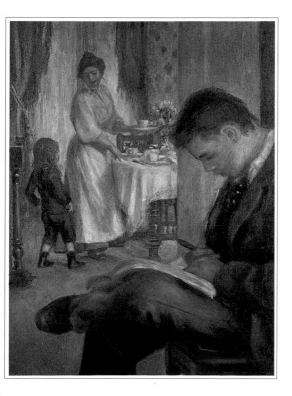

First published in Great Britain in 1994 by
Pavilion Books Limited
26 Upper Ground, London SE1 9PD

Designed by Andrew Barron & Collis Clements Associates

◣

A CIP catalogue record for this book is available from the
British Library

ISBN 1 85793 362 1

Printed and bound in Italy.

2 4 6 8 10 9 7 5 3 1

This book may be ordered by post direct from the publisher.
Please contact the Marketing Department.
But try your bookshop first.